Exposing the Heart of a Poet

Elliot Dennis

Copyright © 2016 Elliot Dennis

ISBN: 978-1-63491-245-7

All rights reserved. No part of this publication may be reproduced, stored in a retrieval system, or transmitted in any form or by any means, electronic, mechanical, recording or otherwise, without the prior written permission of the author.

Published by BookLocker.com, Inc., Bradenton, Florida.

Printed on acid-free paper.

Cover portrait Acrylic on Canvas by Dee Hembre based on photograph by Val Trullinger.

BookLocker.com, Inc.
2016

First Edition

It is easy to get lost in life and this is the thing that makes the people in that life so important. I am grateful to all of the people in my life that believe in me when I don't, remind me when I forget and inspire me to connect to my heart.

I would be lost without you.

Elliot(t)

Contents

Planting seeds ... 13

Again and again .. 14

Misguided .. 14

A guidepost ... 15

Swimming .. 15

Dead center ... 16

Affliction of affection 16

That guy .. 17

Craven ... 18

Riding the wind .. 18

Sharing the moon 19

Silent shadows ... 19

Balance ... 20

Untended .. 21

Memory RX ... 21

Color in my cheeks 22
No love ... 22
One true thing 23
Lost .. 24
Change .. 24
Haves and have not's 25
Stirring .. 26
This and that 27
Waning .. 28
Peeking through 29
Still .. 29
Meaning .. 30
Knowing .. 31
Silent letters 32
Lying in the dark 33
Shadows on the mind 34
Lichtenberg figures 35
A beautiful dream 36
A dark corner 37

Exposing the Heart of a Poet

New day ... 38
At sunset .. 40
No time .. 40
Walk with me 41
Words without knowledge 42
One more step 43
Clear sight .. 44
Above and below, within 45
Echo's in moonlight 46
Satisfied .. 47
You are music to my eyes 48
I was wrong 49
Black holes and life 50
Pathways ... 51
Chasing stars 51
Anatomy of a kiss 52
At the precipice 54
The moon of my heart 55
Seeking truth 57

Lost and found................................58

Right under here.............................59

Teaching me a lesson.....................59

Right there.......................................60

Superimposed.................................61

Night visitors..................................61

Not quite there62

Breath catching63

Light and persuasion64

Time ...64

Just the beginning..........................65

Shining on the dark corners of my heart 66

Remembering67

The rain ...68

Here in the dark..............................69

Jack O...69

Sweet moon70

Salivating on life71

Forget me not..................................72

Exposing the Heart of a Poet

The day .. 72

The Moon .. 73

So close ... 73

Juices flowing .. 74

Just a second ... 75

Sensation ... 76

Trapped in a heart 77

Watching Passion Die 78

Deafening roar ... 79

Raging Inferno ... 80

Offering ... 81

Art of my heart .. 83

First glance .. 84

Awake .. 85

Free as a bird ... 86

Waking the dead 87

The delicious apple. 88

Sun kissed .. 90

What's in a name 92

Elliot Dennis

Out of reach	93
Moving worlds	94
Can and can't	94
Somewhere out there	95
Dream a little dream	96
Long day	97
Kissing ghosts	99
Nectar	100
You can't win	101
Brief	102
Just	103
Time	104
Secret Love	105
Senseless	107
Alive	110
Thank you Capulet	112
Hunger	113
Longing	114
Just breathe	116

A touch of darkness ... 118
Let the rain touch you 120
Haunted .. 122
Distractions ... 124
First kiss .. 126
Shopping tips ... 127
The little things... ... 128

Planting seeds
The quick brown fox jumps over the lazy dog.
Therein lie the seeds of the tales of all life
If you use 1/4 of your heart it is horror
If you use 1/2 then you produce drama
If you use 3/4 then it shall be romance
And when you use it all you have comedy
For we are all fools on the edge of great
adventure

We just need to recall the joy of jumping

Elliot Dennis

Again and again
As I come down from the clouds
My heart seems so far away
I relive today again and again
Hoping tomorrow never comes
I will spend it going through the motions
Trying to remember the last time
As the days tick by and memory turns to shadow
I forget what it is like to believe.

Misguided
I had it wrong
I have longing already
I need you to suffocate it with your lips
Crush it under your heel
While you hold me until the fever has left
Resuscitating the poets heart
That stopped beating when it stopped believing
I need you to know the answer is
Always, anywhere and yes

Exposing the Heart of a Poet

A guidepost
The kiss is a guidepost for the lost
It brings you back to center
Lets your brain swim in the ether
The body grounded in the lips,
Nowhere is home.
The soul lost and wandering,
The kiss is a guide
Giving direction to the heart
In a language not spoken but mouthed
For no ears to hear, but lips to read.

Swimming
My brain is soft as my head swims
A tension in me fights the calm
As I'm pulled into a tidal pool
Life coursing through my veins
While shadows dance in puddles of light
I am content to surrender to the deep
Letting go with my mind,
While gripping firmly with my hands

Elliot Dennis

Dead center
I like the beginning of the rain
When you can hear each raindrop fall
It reminds me of the beat of a heart
As the life falls to sleep in my arms
When the rain loses the beat in the middle
It is the tears from heaven washing my face
I still look up in it just so I remember
The tears aren't mine and I am still the space
At the center of the heartbeat and the rain drops

Affliction of affection
I am a dog chasing cars and humping legs
Panting at the exertion of a dog eat dog world
All I want to do is roll over and bare my belly
The tender part of me with the boot mark
To bury my head in a lap and hide
To feel the soft caress on the back of my ears
To enjoy a dog's life without baring my teeth

That guy
I am the other man
The date you have right before mister right
I can steal your heart and maybe a few kisses
But never get to keep them
I left my heart behind a door I closed
And can never find the courage to knock on
It has been opened for me again and again
But my words turn to letters on my tongue
Hope turns to regret at the loss
I guess I'll content myself with being that guy
And continue to say no more than yes
Until I run out of no's

Elliot Dennis

Craven
I wish I were a better farmer
That I might reap the bounty of affection
I crave a lap to rest my head
In hands where my heart is safe
There is no challenge
Just a place to breathe
No need just stillness

Riding the wind
Don't take my absence as neglect
My being exists always connected to you
Don't take my words at face value
Your presence reduces them to letters in my mouth
Don't take my failure to meet your eyes personally
The sight of you blinds me like the sun
Don't take my silence that you're forgotten
I whisper your name forever to the breeze

Exposing the Heart of a Poet

Sharing the moon
There is poetry to the moon when full
It hovers over my world in phrases
One moment it is the only light by which I see
The next I am wandering in the darkness
It reminds me of you the way it's always there
And yet only present if I am willing to look up

Silent shadows
I am in love with the smile you share with me
That it comes with the silence of your glow
I can endure anything when you show your full self
That I among a multitude admire you
Is but a reminder of your brilliance
I recognize you and the moments shared
In silent shadows of the moon.

Elliot Dennis

Balance
I will fail in death the way I fail in life
I will give no warning as if I am still there
I will give my heart to a girl
On a different circle of hell
I will both encourage and be oblivious
To the advances of the devils mistress
I will fight the devil for control
Not to live but to die my way
I will make everything much harder than it has to be
I will succeed in life where I fail in death

I will feel with every fiber of my being the passage of time
I will trust in my heart while it beats
Even when my judgment is suspect
I will be present when necessary
And absent when possible
I will not survive but I will have lived
An interesting life
And I will have left you all with a story to smile about.

Exposing the Heart of a Poet

Untended

Despair is born in dark corners
In standing pools of loneliness
On isolated patches of thought
Far from the view of humanity
Upend the vessel of your being
Set the world on fire so you see
Run to the end of the earth
And breathe in hard the wind
Despair dies in the ache
Of a body spent from effort

Memory RX

I hear the lyrics in the dark
But don't believe the words
The incessant chant to the beat of a heart
The taste of your lips on my lips
Mingled sweat and limbs
I lost my sight with my breath
But miss neither for your touch
I would to dream it again
But I am awake

Elliot Dennis

Color in my cheeks
Oh precious moon, blush for me
A sign that that my affection is true
The change in your reflection
A celestial treat to feed my waning flame
Hide behind my shadow
So that I know that I can touch you
Expose yourself to me again
And feed the passion within me
So that I too will blush at life

No love
I remember when there was a spark
We were inseparable the two of us
The road was never ending
The adventure just beginning
I went away for a little while
And the spark was gone
The tempest was silent
I miss seeing the world
With my tempest beneath me

Exposing the Heart of a Poet

One true thing
Nothing is ever as it seems
Your understanding is built on all you have seen
Each note you have absorbed through your ears
The numerous scents taken in via the olfactory
All those things that you have run your hands on
Most importantly all the ones you have licked
What colors have you yet to see, and will you know the difference?
What combinations of octaves are just beyond your reach?
What smell is beyond your ability to identify?
What thing did you not have the courage to reach out for?
What taste has never rested gently on your tongue?

If I could wish for you one thing, it would be the kiss.

It is at once a remembrance of all things
While driving away everything you know
You can find yourself in it and be ok with being utterly and completely lost
It is a moment of connection that reaches all the way back to the end
There is on the lips a tenderness that exists for no one but you

Elliot Dennis

Lost
I am not certain where I got lost
I was following the curve of your cheek
When I was blinded by the glint in your eye
I found myself in your smile again
Then started wondering along your neck
When I made my way to your shoulder
All hope was lost

Change
Sometimes the change is subtle
Minute differences in consciousness
The weather, the color, the smell
The time it takes to move from point a
Why point b is so important to get to
Sometimes it is so abrupt it breaks the world
Nothing you see is what it once was
No taste is found in your favorite treat
There is no place that feels like home
I don't know the real differences from day to day
Just that today is different

Haves and have not's
I have fallen, face first, from the top floor of my imagination
I have been engulfed in the flames of my innermost fear
I have jumped off of, out of and into my racing heart
I have climbed bridges to see how far my dreams could reach
I have leapt from them chasing thoughts into the depth
I have hidden inside my skin pretending no one could find me
I have still never been able to escape you.

Elliot Dennis

Stirring

The air stirs, enough to cause my thoughts to tumble
A day like today comes along once in a lifetime
I did with it more than most and less than some
But this was my day to follow my heart
I missed the sky through the clouds
But I have a good picture of the smiles it caused
I felt my cheeks warm at soft words from kind hearts
With a little luck I'll have another day like it
Still brave enough to listen to the breeze
Stir my heart.

This and that
I like being lost but not feeling lost
I like conversations that come with eye contact
I like imagining the wind is from the earth spinning
I like the gravity before the kiss
I like the feeling of falling and soft landings
I like that everything doesn't work out the way I thought
I like that when it doesn't it was because of my lack of imagination
No, I think I love this!

Waning
Can you feel the moons shadow change?
As if the movement of my breath blows out the light
Each day closer to the end of a dream
I can feel the waning of my heart like the moon
Another bite gone from a meal of courses
Another memory faded at the edges like old photos
The energizer bunny playing taps on his little drum
While the child inside finger paints in my head
Climbs things to fall from and licks the world

Exposing the Heart of a Poet

Peeking through
The moon plays with me through the clouds
Like finding a partner in the dark wading in sheets
I cuddle the light coming through the window
As it lands on the pillow next to me
The cold glow makes a specter in the shadows
I swim in the pools of moonlight and
Dream of drowning in the reflection of it
In your eyes.

Still
There is in the stillness an echo
A shadow made of smoke
It carries the scent familiar
Yet completely unidentifiable
It tickles my brain and stirs my heart
Plays on my skin raising the hairs
I drift off to it and dream
The darkness hides something,
Still

Elliot Dennis

Meaning

The sun rises and the moon sets
The breath goes in and out
As pressure builds on the world
There is a thread through our humanity
Taught with discord affecting us all
Our experience as humans
Looking for our place in the puzzle
Sometimes you are the star
Sometimes it is a support role
Sometimes the inspiration
And sometimes the critic
But the play goes on
And you decide what part is yours.

Knowing
I know what I like to look at
The sound of laughter makes me smile
The smell of baking pie makes my mouth water
I cannot resist the soft skin on the inner thigh
And the taste of lips is as sweet as the pie
If I have nothing else,

At least I know.

Elliot Dennis

Silent letters
I question the usefulness of the silent letter
What purpose do you serve without being heard?
But then it may be the silent P
That makes a killer of Pneumonia
That gives Pneumatic that extra oomph
I realize that it is with the silent letters
That gentle poets write about love
Pouring heart onto pages never to be read
That it is with these letters
We impose secret unspoken desire to the universe
I have come around to the importance of this silence
And find no greater joy than an extra letter
That I will never hear on your lips.

Lying in the dark
There lies in the dark a quietude I cannot find
A space where the dreams take over while I watch
The faces and feelings pouring out like the rain
I bubble to the surface just long enough to breathe
As the sounds of wild creatures brawl in the street
There lies in the dark a quite soul
Where I should be

Shadows on the mind
There lies in the reflection none of the body's remembrance
No trails made by nails that fade with the soothing touch
No mouthwatering trace of strawberries, sweat and vigor
No remnant of the sound of your excited heart or easy breath
No intimation of the scent of jasmine and citrus on your skin
No silhouette of the lines or curves that perfect your form
No lingering memories of the echo of a kiss
My joy is on this side of the mirror
Where reflection makes a playground of my senses.

Lichtenberg figures

There is a spark within us that follows a trail
Emblazoned by a mystery all the world seeks
Some huddle in the dark keeping warm by the spark
Others drag their feet through the carpet of life
Sharing the spark with other sparks that they meet
I like the idea of being born of a bolt
A tesla coil arcing to the beat of a heart
In the dark a warm glow reaching for a conductor
There is a charge found on rare occasions
That takes what I give and magnifies it
Before giving it back

Elliot Dennis

A beautiful dream
Awakening to a world on your own terms
Moving small things to make room for the big ones
The world is a puzzle and all you can do is find your place
Once you do, you become the edge for others to hold on to
You become strong for you are connected to the whole
The beauty that is the big picture becomes clearer
You find that you are surrounded by pieces that fit
And the poetry of the wind plays through you
The warmth of the sun can reach you
The love that resides within you becomes
 The arms you can fall to sleep in;
To dream

A dark corner
There is a place, a little away from the world
In a dark corner of my mind, where I find myself
It is a pond with no ripples
No thoughts required
I go there because you are not there
And I find that I am not there either
There is nothing required of me and I require nothing
I die a little But when I rise, rollover or open my eyes
I see that the piece of me that is gone
Was never really me to begin with
It makes me wonder where I am
Why I chased you away
You are here;
Is a cavern of mystery when you are;
Lost in the world

Elliot Dennis

New day
They sing of Auld Lang Sine in the dying hours of another day
Should you take a piece of me with you into new waters
I hope it is the piece of me that knows your strength
The kind and gentle spirit you are when you are willing
The beautiful being that the world needs to complete the puzzle
I take with me all of you and some that are everywhere
I take some that have built my muscles and mind
And some that have broken me down brick by brick
I take the challengers and the accomplices
I take those that have awoken me and those that put me to bed
I take the healers and those that I have scars to remember

Exposing the Heart of a Poet

I take with me the wounds that won't heal and
the heart that won't stop
Into a breach once more I take with me the
memory of a life
With branches like a tree and covered in
memories like leaves
Reaching out ever more again up and out
For a sky where the sun rises and sets
Each time taking my heart and giving me another
piece of magic
Happy New Year and thank you for the old ones.

Elliot Dennis

At sunset
Each day I die a little, we all do
It is in the nature of the breath
To be taken in and then expelled
Take heed of the way you breathe
Is the breath shallow, high in the chest?
Does the belly expand as if full?
How often do you find your breath taken?
I am inspired when I open my eyes
And reminded once again,
Don't hold your breath!

No time
Life ticks by one second at a time
Minutes remembering moments
Hours struggling for the future
Days spent undoing the past
Months seeming lost in a bubble
Years melting away before you know it
The heart doesn't tell time except by beats
And as the years turn to decades until eternity
Remember you live in every beat of my heart

Walk with me
I will greet you and welcome you to this place
I will walk you to the right door so you don't get lost
I will walk this path for all eternity and a little more
Under the blue skies and grey, under sun and moon
In the middle of chaos and in the peace and quiet
I will always be here in this lonely place
So that you know you are not alone and never were.

Words without knowledge
Speak of things you do not know
Speak of love and how it frees from all earthly bonds
Speak of world peace and the kindness shared by all
Speak of the sight of the other side of the universe
Speak of things that only exist in the minds of wanderers
Speak to me of impossible things, for this is what I crave
Speak to me with passion and knowledge
Of things we know nothing about.

Exposing the Heart of a Poet

One more step

There is in each step a dream
The little picture in your head that floats away
As you follow it to the end of the world
You keep the fire in your heart stoked
Hope coursing through your veins because you dream
It is in the nature of being human to lie down
To rest our aches and nurse our wounds
This keeps us ever able to fight, to keep fighting
Just don't let your eyes stay closed so long
That you forget to dream, to fight
Don't let the fire in your heart go cold
In the dark the only dream, another step

Elliot Dennis

Clear sight
More than anything I want a clear view of you
To watch as you hover over a world you're not part of
In the night sky with all of the other dreams like you
I want the clouds to part and the darkness absolute
So that each pinhole in the curtain of night can be seen
I there, lying on the ground, basking in your glow
Waiting for the tears of dying stars to fall
A clear line of sight to your falling
A reminder of mine

Exposing the Heart of a Poet

Above and below, within...
There is at dusk a moment where the light fades
The darkness comes and spreads to everything
It is a divine moment to see what we are a part of
Time to bathe in the space between the stars
Some spending their final moments to join us
Falling like we do when we find ourselves without
The light returns and you find yourself lost
The star that guides you unseen in the sky
For this moment be here, lost
With the rest of us.

Elliot Dennis

Echo's in moonlight
I love basking in the rays of moonlight
It brings back memories always near the surface
Flesh with little drops of moonlight cascading down
Lips soft and full like she stands before me now
Whispers in the dark like there is a world we hide from
The gentle pull as if a tide lives in the still waters
The reflection of her light in eyes you can drown in
Sinking slowly into the midsummer night's dream
Holding fast to something that keeps me from floating away
There stirs in the moonlight a song that can only be heard if you're listening.

Satisfied
There is little satisfaction in being satisfied
There is no such measure as good enough
When the great puzzles are solved the mystery is gone
Better I think to stay hungry with room for more
I'll not think I'm not good enough merely that I am good
The hearts I leave impressions on are impressionable
And the indentations left on mine that it is still soft
A gentle spirit I let in rested there for a moment
The rule in creation is measure twice and cut once
Ensure your measure true if the first measurement is
Not good enough

Elliot Dennis

You are music to my eyes
There is a moment in the dark when the music starts
I can see you suspended from the notes hanging in the air
In between bars, the breath on the verge of your lips
As if the lack of light could hide you from my senses
Four of the five working harder to expose you to me
My memories fill in the voids so it is no mere shadow I reach
The bloom of the cadence, a catalyst to remembering
Right before my eyes and on the tip of my tongue
Is a song without words played out in the beat of my heart

Exposing the Heart of a Poet

I was wrong
I commented the other day that I want to be in love
This statement was misguided in so many ways
I am in love, constantly and perpetually
I am in love with how wholly I am owned by this cat
I am in love with taste and the flavors that the world has
I am in love with the sounds that greet me with consciousness
I am in love with when I let go; the world conspires to hold me
I am in love with the memory of sensations and of the life spent collecting them
I am in love with the faces of the people I know and some I haven't met yet
I am in love with passion and inspiration that lies in all the strangest places
I guess what I should have said is,
I want to be in love always!

Elliot Dennis

Black holes and life
Things occur in the span of a life that create a void
A black hole that disappears all that touches it
You may turn and simply try to forget, you won't
You can try and fill it with life but the hole remains
It is the emptiness in the ring that makes it wearable
The nothingness between particles what make it
It is the life that surrounds it that makes it bearable
It is the perforation in the sky that lets the stars shine
Nothing is ever destroyed it just changes
From something to nothing and back

Exposing the Heart of a Poet

Pathways
There is a pathway in my brain
It is a glorious thing to behold
The past, the present and the future
Bound by sunsets and whispers
The stars fall from the skies like rain
The flavors make the mouth water
It loops back on itself for a time
I like to walk this pathway
Apparently so do you.

Chasing stars
I wait watching the sky for something more beautiful to happen
It is like looking into your eyes waiting for them to ease shut
Like chasing your heartbeat along your neck with my lips
Slowly one by one they fall from the sky
A reminder of you landing gently in my arms
The pace quickens as the heavens rain down
Like my heartbeat at just the thought of you

Anatomy of a kiss

When does the kiss actually begin?
The moment you begin to watch how the lips form words
To wrap themselves around the syllables as they part ways
When you first ponder the touch and texture without sound
Perhaps when you begin to feel the gravity pull you in
The anticipation as you stand eye to eye as time slows
Like swimming through seconds on your way to meeting
The first touch going just passed center and then easing back
You find the exact right pressure and then begins the level
A little to the left, a little right and then farther to just right
The moment the lips part and you taste nectar for the first

Exposing the Heart of a Poet

Your teeth reach out and graze the tongue the lip
Like being in space, the seal the only source of breath
As if losing the contact would bring a sudden agonizing end
The release when you are a just within reach but still recovering
The moment when you go back in amazed it could get better
I like the study of anatomy!

Elliot Dennis

At the precipice
There you are balanced on the tip of my mind
Like an echo of a memory
Reminding me of something
The thoughts of a passionate life once removed
There, in the center of a beating heart, you are
Faint images of tumbling head over heels through space
The darkness in the box waiting for the fall
The heights purely imagined but thrilling
The landing from eyes down and totally fearless
But then it beats, bringing back the image of you
Climbing on the furniture like you have never fallen
Like the heart within has not been jaded
What once was an echo now takes form
A wall, a ladder a rope to scale to heights once home
A reminder of breathlessness, fearlessness
And the beat of a heart jaded but not broken

The moon of my heart
It seems like forever since I have enjoyed your gaze
Perhaps it was me, distracted, that missed the opportunity
To bathe in the warmth of your glance, if for a moment
It brings to mind memories, stripped in the darkness
The warmth of the water a stark difference from your cool touch
Hands reaching, with held breath, to expose you, myself to the light
It happens when you are present
The heart beat rises
I wish to howl but with my heart in my throat there is no way out
I promise myself each time I see you that I will not close my eyes
I will hold that gaze tenderly until you disappear again
I am weak for I always turn away first
But you must know

Elliot Dennis

You are the moon of my heart and as long as it beats
You will live with me.

Seeking truth
I am a lie
Not some simple little exaggeration
A web that has taken a lifetime to spin
The distaste I have for this life is not me
It is for holding the lie tight, when I'm afraid
Love, real love, makes you forget about "me"
If you live with it, it is outside of yourselfishness
I know the truth, in so far as I recognize the lie
I am afraid of the truth, not the love, I like that part
I am afraid that I can't believe the lie anymore
I am learning to like that part too

Elliot Dennis

Lost and found
No person should ever feel lost in the middle of their life
That person in the mirror vaguely familiar in a distant way
Like the stars, a memory of a source that doesn't exist
The body meant to be the anchor in a race to the end
The baton coming from a dream of possibility never ending
It is not a race you will be reminded and yet invest everything
So that when the breath is caught you can bask in the heartbeat
Let the walls you build around you be to rest from exerting life
Let the door be open to all that wish to enter
And let your heart rest comfortably in the hands of another
Thank you Dulcinea

Exposing the Heart of a Poet

Right under here
Under the right moon the heart remembers special moments
It makes the body light and the feet follow the rhythm of the world
The eyes close and the reflections play back on the eyelids
While the heart beats in time with a song
Right under here, in the light of the full moon with a weary heart as a pillow
You dance.

Teaching me a lesson
I learn my patience from the moon
With moods waxing and waning
Awash with despair at the loss of light
Nauseous from the spinning thoughts
Tumbling through the darkness never ending
Yearning for a release from my own desires
Overwhelmed by the joy of loves return
Under the light of the full moon.

Elliot Dennis

Right there
It never leaves because you forget
It doesn't die if you don't water it
It is not scared of pain
It is not attached to that which is in front of you
It has not been discard with that which is behind you
It lies in the spark that beats your heart
In the twinkle in your eye
It is in the tiny space where your skin presses on the world
When you awaken know;
There is love in the world for you!

Exposing the Heart of a Poet

Superimposed
There is an image forever in my vision
Overlaid on the hard world your soft visage
It is your image I see everywhere I look
My lips infused with the sensation of yours
And the scent of vanilla a constant reminder
Gone is the time of being alone in the dark
I am content to look upon you always
Never once questioning your belonging
Even now in my private thoughts

Night visitors
I hear the subtle noises you make in my ear
Pulling me from the dream to be with you
I can feel the skin get tighter, swelling
A single touch causing deep sensation
I rise and search for you in the dark
The light goes on and I am alone
Writhing in the sheets sleepless
One little touch from you lingers for days.

Elliot Dennis

Not quite there
I am a lone wolf
Or perhaps just a lost puppy
I sniff around the world trying to find the scent
It is home and comfort and safety
It is a place to take off the mask and let it all hang out
It is the place where my hat is hung and my heart is
It is a little disheveled and slightly a mess just like me
In it are things that remind me of yesterday and a whole bunch of tomorrows
I am alone with my thoughts
But never alone.

Breath catching
Once a day, usually more
I am caught by something that catches in a heart that still works.
It is a story that fills me with empathy
A child's curious glance and often the sun and moon.
This is the way a life should be
Not in the way that something occurs for these things happen.
But in the fact that a heart should work and the breath should catch

Because the heart of the man still works.

Elliot Dennis

Light and persuasion
The light never goes out, the influence never fades
I close my eyes and the flashes are always there
The light in your eyes persuading me to remember
The moon gleaming down, just a whisper of your twinkle
The sun a reminder of the warmth I cannot feel
My heart is convinced and filled with love and
A memory of light

Time
A second has always been a second
A minute always measured by these
An hour passes when you stack them
A day when twelve meets twelve
A month a fickle number of these
And years when a dozen pass
How is it that these things change in your eyes?

Just the beginning
I am caught in the midst of a memory
Lingering in the senses that have been awoken
Opening my eyes to the desire of my heart
Vainly keeping my eyes closed so the dream will not end
Even now, awake, my soul aches from the loss of the vision
Youth calls me to remind me not to become brittle
Over the trials that must be present in a well lived life
Understanding that give and take happens in every breath.

Shining on the dark corners of my heart
There is a space that can't be reached by the light of the sun
It is the deep place within me where hangs your image
It is the place where always is heard the echo of your voice
It is the place where the taste of you is always on the tip of my tongue
It is the place where the influence of you makes me better
I visit this place in the dead of night by the light of the moon

Remembering
There was a time that the silence was ok
It was the comfortable void among friends
No utterance necessary as the thoughts were shared
It was falling in like with someone because the love was already there
We grew and aged and loved and lost
The silence became a tool to fix something that wasn't broken
We became afraid of showing ourselves because it hurt
We forgot the empathy needed to nurse each other back to health
Remember ,if you can, the love of a child
The willingness to be authentic and unstoppable
That all stories are love stories and there is always an ending
That once what has passed is forgiven the future is bright.
Remember you are loved.

Elliot Dennis

The rain
There is something in the rain that screams of you.
The way that it seeps into my core, lingering in my bones.
The way that it makes my flesh raise and my heart race.
The way that it washes away everything before it.
The way it touches my face, my neck, my heart.
The way it leaves me exposed and ready for anything.
I am grateful for the way the rain lingers
In my head with you.

Exposing the Heart of a Poet

Here in the dark
I look for you in the dark
Just a moment ago you were beside me
I wake from one dream into another
It is not until I come home to my body that you are gone
I welcome these dark moments to see you
To walk through worlds that don't exist
With courage long forgotten

Jack O
The moon is my jack o lantern
I slip through the night making my way to your door
My plea is for something I know is no good for me
I change my face returning again and again
To see the light of the lantern in your eyes
I will take the treats you have for me
And slip into a dream of ghosts, vampires, witches and you.

Elliot Dennis

Sweet moon
Oh sweet moon how I have missed you.
I had forgotten the gravity that you bring
The draw as you stand full before me
I get lost in your gaze reminding me of oceans in paradise
A reminder of your touch, the water pulling me in completely
The warmth of it filling me, my heart fast and full
I find myself crawling along your surface the touch like silk
Slipping through my fingers like the fine sand at your edge
I know I have but to wait to glimpse you again as you hide
Behind fast moving fog of the day as I wade through life
But the memory is barely enough to sustain me
Until we come face to face again

Salivating on life
I was choking on the bitterness of a memory
I sat watching the fruit ripen past its prime
I was stuck in a yesterday that was but a moment
A moment that will last forever for I was alive
I was hungry for more and willing to be sad
Forgetting sadness fades into bliss by contrast
And then
I looked into words that were a mirror for me
I lifted the ripened fruit to my lips and remembered
The fruit is hard until you are patient
Then the shell turns soft to the touch
The skin wants to fall away like tears
My lips peeling away the layers of time
My teeth finding my heart in yours
The juice bathing my aching soul
As I devour the thought of forgetting
The fruit will rot like my heart
Until I remember to use my lips
To express the heart that beats within
And taste the life that was waiting.

Elliot Dennis

Forget me not
Sometimes I forget
I forget that listening does not require a reply
I forget that life has a rudder and I'm driving
I forget to be a friend to someone who needs one
I forget to stop and look where I am
I forget that I am not alone
I forget that words shared help us along
I forget to write.

The day
The beauty of the day is not lost on me
Thoughts of love granted and denied
Thoughts of loss and guilt of survival
I gifted life treated carelessly
A seemingly endless line a circle
Of the same mistakes made again
The beauty of the day is not lost on me
But the meaning of it all is lost inside me.

Exposing the Heart of a Poet

The Moon
In the sky sits the barest sliver of a moon,
Like the eye caught in the crowd.
It is the last shred of hope
Or perhaps the beginning of a smile
I lose myself in the cycles of it
Does it wax or wain
It matters little since I am here
In the deep blue smiling back

So close
I can hide my shivers in the cold
It comes from your proximity
There is a vibration from the closeness
An octave higher but in perfect harmony
I am still lost in your grasp
You hold me up by touching my arm
Your hair on my cheek as I breathe you in
How do you make time evaporate so?
How can you be right here
Yet so very far away?

Elliot Dennis

Juices flowing

Thoughts of you bring a heat to my cheeks
My mind on a slow simmer with visions of you
The heat rising until the juices drip into my mouth
A lubricant to get your flesh to slide past my teeth
As your image dances in my brain I remember your touch
Molten thoughts gliding down the ghost trails left by your nails
I am on fire with the thought of you slipping through my fingers
My palms moist from cradling you in my grasp my breath short
My thoughts roiling with the images of you lying before me
Your skin glows with excitement as you bare yourself to my desire
Our blood boils as we surrender to the urgent need for one another

Just a second
There is in a breath a timeless experience
It is the moment I was close enough to breathe you in
It is the very instant that I first touched your skin
It is the kiss that awoke me to the taste of you
I can trace the path of my teeth on the raised bumps of your flesh
I can read the past in your breath the heaving in sync with my heart
I can follow your scent from initial excitement to final surrender
There is in my senses a road map to the rising level of passion
In this moment

Elliot Dennis

Sensation
Every breath is filled with you
As my chest rises and my skin tightens
I am reminded of your head resting there
As I exhale I see the air dimple your skin
The air being pulled through my mouth
A reminder of the taste of salt on you
As my chest falls and my pulse rises
I feel your heartbeat on my tongue
As the blood courses through me
I remember the feeling of you in my arms
Every beat of my heart a reminder
Of you.

Trapped in a heart
I sprung the trap and your eyes captured me
Since that day I have been crippled in my daily life
My mind never far from the lingering nature of your being
My legs working hard yet never bring me any closer to you
My breath short with the thought of you in my arms
My heart a cage I keep you in so I might be near
My eyes seeking a vision they only see when they are closed
I have no concept of hunted\hunter
I just know that my spirit is tied to yours
A cosmic Gordian knot
The heart deciphering what the mind cannot know

Elliot Dennis

Watching Passion Die
Do we kill this thing?
Or do we ignore it and let it die
Do we smother it with love?
Or ignite it with our passion
Watching it burn to nothing
Do we hide it in a dark place?
A heavy weighted breath
Taking less air with every beat of my heart
In its passing perhaps we can forget
The calm found in the simple touch
The electricity created when lips meet
The hammering of the heart of two spoons
The shock of pleasure with a subtle caress
Negligence the weight on my chest
Fear the poisoning of a dream

Deafening roar
I am so keenly aware of the beating of my own heart
In my intensity it seems I can hear the moons glow
The sky's color at dawn a song ringing in my ears
The sounds of words that have no meaning all around
I am swept away by the deepening silence as time passes
I hang on the emersion of a single word in my direction
I hold my breath in anticipation of a pin that never falls
It seems it is not my own heart I listen for in the quiet.

Elliot Dennis

Raging Inferno
It seems my arrogance knows no bounds
The thought that an awakened heart could be ignored
My body rails against the quenching of the fire inside
Muscles chorded, bound and tied to tether me here
The thought that a supernova might share the sky
With stars just a faint echo of the possibilities
The inkling that I have the fortitude to restrain this
A mockery of man and his ability to build walls
I will but let the embers burn down, waiting
Until I achieve the heat so that I might temper
This new found metal into a suitable blade
With which I will rail against the world
Fed by this raging inferno that both feeds me
And feeds on me.

Offering
What do you offer me?

Nothing

Except the awakening of a dying warrior
The fight blooming in my heart to go on
The willingness to give today my everything

Except the reintroduction to my animal self
The ability to rise from the sand and hunt
To find that in the world that will sustain me

Except the vision to see the sun set in the west
For though the sun will rise and set without me
For those with eyes for it there is splendor

Except the ability to feel passion
About the touch of another person
About the world, imagination, creativity and love

Elliot Dennis

Except your time, your thoughts and your body
Your time that is valued by everyone
Your thoughts only shared with a select few
Your body which holds all that is precious to me

You offer me nothing but everything
For you are everything to me.

You may not have offered it
But you have given me, me

Exposing the Heart of a Poet

Art of my heart
Oh that I could sing
So that you might hear the harmonies playing in my heart
Oh that I could play an instrument
So that you might hear the notes resounding in my soul
Oh that I could draw
So you might see the details I see when you are here before me
Oh that I could paint
So you might see the explosion of color on the sunset of my mind
All I have is my words
So I will string them together
In a way that reminds you
Your voice is the song
Your words the chords
Your presence the art
Your person the masterpiece
You my heart, are why artists exist

Elliot Dennis

First glance
What is it in your stare?
That has so irrevocably transformed me
I have experienced an awakening of heart
I was distracted from the distraction
And found in me a piece I thought long dead
The vigor in which you live has infected me
And I am completely under your spell
The world it seems conspires against me
I can now longer claim to be jaded
I can no longer ignore inspiration
Any more than I can avoid your gaze.

Exposing the Heart of a Poet

Awake
There is this thing in life
That will awaken your soul
If you dig deep you might find it
If you are lucky it might find you
Once it happens you are driven to create
The colors are more vibrant in all things
And your mouth will water at the taste in the world
As this day, a gift, waxes endeavor to dig
And as this day wanes let your soul awaken
So that in the New Year you will find passion
May each of us find that in the world which drives us
So that tomorrow we know that anything is possible

There is love in the world for you!

Elliot Dennis

Free as a bird
I want to pursue you
Even though I know you cannot be caught
You are a colorful bird flying through the rectory of my mind
How you fly so free bringing color back to a black and white world
This place used to be filled with sunlight filtered through stained glass
And leaving it was to a sky painted by divinity with colors that don't exist
There are no hymns sung here now and no longer a palette waiting
Until this beautiful bird came in and filled the halls with her song
I pursued her to free her from this place and set her free outside
This is where she led me.
Outside, breathless in awe of a sky the color of a well used heart being torn apart.

Thank you little bird.

Waking the dead
I am destroyed
I find myself ineffective or it seems irrelevant
I will bury myself in your neck until your pulse revives me
I will find myself invigorated with your scent
I will restore my strength with the softness of your skin
The taste of you will feed the ache deep within me
I will be restored with you coursing through my veins
Beating a once empty heart

Elliot Dennis

The delicious apple.
I know why the apple is called delicious.
She is perfection in her form hand painted by nature to entice you.
The skin is flawless with a gloss that demands attention.
She grew up in a place with a beautiful view and was kissed everyday by the sun.
When you hold her it's as if her curves were made for your hand.
If you place her to your lips and inhale you can sense the delight in store.
You do not want to make a pie from this but feast in its perfection NOW.
Your lips part tentatively and caress her skin your teeth sliding along the surface.
You bite the skin slowly so that you can feel the juice pass your lips.
You reach the tender heart and her taste carries the flavor of the sun.
Your juices begin to mix with hers and you stop for a moment close your eyes and ponder the word DELICIOUS.

Exposing the Heart of a Poet

You roll it around in your mouth enjoying the difference between the taste of skin and the heart.
You bite again because once was not enough and you want more.
Your hand becomes sticky with her and you lick your fingers in between bites.
She leaves you satisfied and yet wanting more.

Elliot Dennis

Sun kissed
Why does the sun kiss the orange?
She stands out from all others with her bright complexion calling attention to herself.
She hides behind thick skin but only to the casual observer.
The facade is soft and easy to break through to the sensuous center.
Her skin is pebbled as if she spends every moment excited.
When you hold her cupped in your hand you can almost feel her trying to get out of her skin.
The moment you pry into her you can feel the moisture pour from her skin.
Once you have exposed her completely you cannot help but admire the perfection that she is.
It takes pressure and finesse to separate the folds coaxing them apart so that each can receive like amounts of your attention.
When you take it in your mouth the skin slides smoothly across lips and tongue.
With the slightest pressure of your teeth the

juices begin to flow freely.
It is as if you are being kissed by the sun so you kiss back sucking ever so slightly to ensure you miss nothing.
As you devour her again and again your senses alive with her flavor on your lips you can feel your pulse rise.
You taste the stickiness on your lips and fingers while holding what's left of her in your hands.
Now I know why the sun kisses the orange.

Elliot Dennis

What's in a name
We name things
So that we can define them
So that we might be able to understand them
So we can possess power over this named thing
Talk to people and they will say it does not exist
It is the stuff of fairytales and magic
It is the stuff of black holes and milky ways
It is us and them and the water and the trees
I am grateful I don't knows its name
I would not have power over it
I don't so much wish to understand it
My desire is to explore it, discover it
The way that I would explore your scent
And discover the way it changes in desire
In the manner I explore yours lips
And the change made when your blood is pumping
Let us call it "this" and recall the immortal words
"That which we call a rose by any other name would smell as sweet."

Out of reach
If only my hands could reach you
I could remind you of the rest of you
I could show you the gentle ways of rough hands
As I caress the cheek and follow the jaw
The path of your hair follows the gentle slope of your neck
Your head cupped in my hands as if to drink you from my palms
First contact a test to find the surrender in your kiss
The teeth separate to take in the soft lips
The grip urgent as I try to quench the thirst
I pull my lips back just to breathe you in
It would be a tango if I could move
Cheek to cheek we are trapped while I devour your scent
The gentle beat of your heart within tongues reach
The bite just enough to pull the flesh to my mouth
The beat quickens as I find my fingers entwined in your hair

Elliot Dennis

Moving worlds
I am under your control
My mind is my own but my body responds only to you.
My hands grip at your command like an arcade game
My arms lift sweeping everything into the air
My shoulders move the world according to your whim
My legs pumping to get everything into position
Straining muscles at ease with your every word

Can and can't
I know how to speak my mind
My heart loves arranging letters
My eyes see things others don't
And silence is a place I spend my time
But I have trouble with my hands,
I can't seem to let go

Exposing the Heart of a Poet

Somewhere out there
Somewhere out there I lie awake with you
I wonder how it is, only now, this thing occurred
You have always been there, always been here
We have passed again and again unnoticed
Like a cold front meeting warm on many occasion
Each doing what it always does save this time
Creating this perfect storm in my chest
The tornado in my head reducing everything to you.
You have always been somewhere, out there
I am not sure what to do with you, here.

Dream a little dream

The sun climbed in bed with me this morning
I was in the grip of a dream and the sun had a face
My senses conspired with my mind to play tricks
The nuzzling at my neck was warm and soft
As I curled in on myself there was a heat not mine
I could feel her, lips brush my face and the heat rose to my cheeks
I open my eyes to see this creature doing these things to me
Only to find a puddle of sunlight, 2 cats and me.

Long day...
I long for the day to start mere moments before yours
To see you warm and at ease laying in a bed of darkness
To watch the subtle twitch that says your dreams are fulfilled
I long for the chill of the morning before the days begun
The steaming cup lifted to patient lips to clear the cloud of night
To conspire on a day filled with possibility and adventure
I long for the sound of your voice on the mundane
The change in pitch as you describe spoiled conspiracies
As the tension escapes and you ease into desire
I long for Rembrandt skies turning to van Gogh nights

Elliot Dennis

Watching the waxing, waning moon as the stars rain down
Our ids watching the ids until the night overcomes us
I long for the gentle caress of hair on cheek as I greet your neck
The feel of your skin and the scent of you as you curl into me
The gentle slowing of your breath as you fall asleep in my arms

Maybe not long enough...

Kissing ghosts
I don't know what life you had, but I see you
I respond to you though you are not really here
You look at me and something deep inside me responds
It is the piece of me that, like you, is me
Your outline is forever embedded on my vision
The spirit disappears when my mind reaches out
In my head there is warmth in you I cannot feel
Eyes like night, that make me pause and awaken
Skin with the shimmer of the autumn moon
My lips find lips that are not there

Elliot Dennis

Nectar

There is a liquid that when it is tasted you will be transformed
It is like the sunshine and your whole being will bend to it
It is the racing of a heart striding through meadows
It is the taste of a lovers lip when filled with passion
It is the silvery moon spilling pale light on an open heart
It is vigor, exploration, fear, hunger and satisfaction
Let it touch your lips, let it slide across your tongue
Let it seduce and intoxicate you for once you have tasted it,

Nothing will ever be as sweet!

Exposing the Heart of a Poet

You can't win
If you don't play.

That jackpot cannot be yours if you don't ever pick a number and buy a chance.
That train will never pull into the station if you aren't on the platform to meet it.
Those eyes will never meet yours if you don't join the crowd and raise your head.
That heart will never be yours if you don't bare your own showing that you will protect it.
Justice will never be yours until you can look outside of yourself to find it.
Freedom will never be yours until the price you are willing to pay for it is...

Everything

Elliot Dennis

Brief
There is a moment; perhaps moments in a life
were you see that nothing is missing.
It is not that this could do with a pinch of salt or
just doesn't have that something.
It is not that you can't touch her skin or
Look in her eyes whilst being held by her voice.
It is not that if, it were just a little different it
would be any better.

It is that the air fills your lungs and makes its way
along the ways of your body to make touching
the world a thrill.
It is that the taste that hits your tongue is the
same one that has fed generations of smiles
It is that there is a moment were what is, is, was,
was and anything can be

It is not that they are brief
I just wasn't paying attention.

Just

It is not just that you are beautiful and smart.
It is that of all the beautiful sites in the world
there is nothing more captivating.
It is that though I have seen you before,
Each time I do I am newly inspired.
It is that like looking into the sun,
You leave shadows in my vision when you're gone.
It is that there is a place in my mind
That traces your form while it beats my heart.
It is that you speak my language
And in a way that speaks to the me that listens
It is that your insight sees through the world
In a way that makes everything simpler
It is that you do not need me to explain the world to you
But you let me narrate it
It is just that though there is a piece of me
That wants to hate you,
I can't

Elliot Dennis

Time
I hear it said there is a moment that is like death,
In the good way
Look into the night sky; each star is one of
infinite possibilities
A whisper, a dream, a glance, a breath, a sigh, a
deep exhalation
Take the time to pay attention both to the sky
and your life
Stand for something, lie down for no reason.
Find yourself, lose yourself
Get caught up in something and swept away
Explore your inner depths and outer limits
Take a moment
Someday is code for never
Love is code for forever

Secret Love
I know of no love that can be kept in and unspoken
It is not to be a whispered dirty little secret.
The passionate intercourse held in hushed breath is but the budding,
The beginning of newfound love
If kept in dark places it wilts before the fire starts.
It fades from lips and memory unfed by dreams
Love is the roof top chase with hearts thumping
The body thrown from cliffs and caught in gentle waves
Washing away sorrow in the never ending sea of passion
The parade, charging arm and arm through anything that comes.
Howling cats that awaken all those comfortable in their death
The stirring of those that let life seep slowly from their hearts

Elliot Dennis

I do not know how to adore you quietly
Nor that I would if I did
Every day you must know that you are loved and every moment kissed
Every hour longed for and every second missed

Senseless

Do you know how you touch me?

Your existence is enough to remind me to be grateful for my senses
To see you enough to make my eyes water and focus on your every curve
My eyes take in the shadows that fall on the edges of your form
The curve of your cheek, the color of your eyes the fullness of your lips
To smell you on the wind like a sailor smells the ocean, the scent of home
You fill my head with your scent like the prey to the nose of a wolf
The smell of flora and citrus and lavender and time layered like wine
Your voice reaches my heart like atoms colliding to make it beat faster
The sound that of an angel with the inspiration of the devil
To touch you is almost too much, first contact, like reaching for a ghost

Elliot Dennis

Barely enough to be called contact to make sure you are real
I gently touch the curve of your face tracing your lips with my thumb
My hand sliding slowly down your neck to the curve of your shoulder
Adding strength to my exploration I find your substance
Each moment more urgent
I caress your arms as I find my way to your hands lifting them to my lips.
My lips apply more pressure still as I introduce myself to you
I begin my understanding of your flavor by breathing you in
As I raise your hands with my own they are bound up and over
Exposing your flesh to me, first I kiss the upturned cheek
Then I nibble the soft flesh where your ears meet your head

Exposing the Heart of a Poet

I drag my lips down your neck as my tongue darts out to taste you
My insistence grows as I bare my teeth and devour all of the soft places
You are supported by my hands as you are destroyed by my mouth
I use all of my senses to draw you in and feed on you
Until you are left senseless.

Alive

Sometimes it's cold inside.
Like my core has stopped spinning
It becomes solid and brittle.
My fuse gets shorter
I am always just at the point of exploding
I grow tired and weary of everything
That wants a piece of me

Then:
I see the stories we tell
I see her face
The smile reaches all the way to her eyes
I feel the hands of a stranger
Trace the contour of my arm
Not wanting to break the gentle contact of
knowing and discovering
I hear the sounds of a soul praising love
With the voice of an angel
My head grows light and my heart full
My skin raises with goose bumps
The hairs standing on end

Exposing the Heart of a Poet

My mouth closes, my eyes gloss over and I breathe
For I am alive!

Elliot Dennis

Thank you Capulet
How lost the longing for when I did long last
How to peer over stonewalls to greener past
When all before is but untamed wood
How lost the cause when cause is good
Loss and longing never cease
Oh to have but a focus that blinds me to me
Becoming a single point of light in the darkness
Oh rejoice the loss when outside of me;
Found is the lusher green of cause
A simple thing to lie with eyes blind
Using the mind to see she that is all to me
What matter that memories play
Taunt with bliss our joining
All that is fuel for passions forgot.

Hunger

The craving I have is for something my lips and tongue have tasted yet never seems to fill me.
It is a flavor that changes with the mood and the urgency with which it is devoured.
Sometimes it is liquid salt beading its way down the throat of a hungry beast.
Sometimes it is the flavor of vanilla lapped off the softness of rose petals.
Sometimes it is honeysuckle or peach or cherry drawn from the fruit itself.
Oh tongue that tastes and lips deny that anything so sweet should find its way here.
I feed and yet crave more
The changing essence of this hunger.

Longing
That thing that happens from across the room, this is the souls longing.
It has nothing to do with expectation only satisfaction.
It is the gravity of the heart being pulled at by another
Whose polarity is shared and affects every cell and atom in your being.
It is not quick or slow and cannot accurately be measured, detected or quantified with the conscious mind.
It is at once instantaneous and eternal and happens only to the music of a beating heart.
It is a tickle in the mind of remembrance of the unknown.
It is a tingle on the skin as it traces the smoke.
It is the scent of something familiar that makes us long for the moments of comfort we have had.
It is the sound of a melody that plucks at the heartstrings to a tune that will forever be stuck in our head.

Exposing the Heart of a Poet

It is the taste of freshness, filled to bursting with juices that make you experience the time in the sun growing.
It is the site of poetry; in color and form.
It is what artists; writers, musicians and we seek without ever looking.
It is inspiration and it comes in the form of longing.

Elliot Dennis

Just breathe
It is a strange feeling to breathe someone in.
To have them feed your mind and muscles as the blood pumps.
I am breathing and it is the slow breath of anticipation as I gaze at you.
Tracing your form with my eyes my breath slows even more and I can feel warmth gather deep inside me.
I reach out and the breath catches at the electricity in your touch.
I explore your body, your scent your taste
I can feel my heartbeat rise like the warm up before the run.
I take measured breaths to ensure that I don't lose myself as I pull you to me.
I press myself to you and my heated breath is heavy on your neck
I listen to the low moan that comes with your exhalation.
The pace of our breath rises together as we roll in each other's arms.
You feed me like a bellows with your breathing.

Exposing the Heart of a Poet

I draw on your excitement like a man trapped
beneath the waves when he breaks the surface.
My heart hammers in my chest as we find
rhythm together and my breath escapes me.
Spots swim in my eyes as I struggle to inhale but
there is only you and my mind explodes.
You lie on my chest finding your breath again.
It rises and falls rocking you into a deeper place
of relaxed.
I breathe you in and I hold it
Like I hold you in my arms.

Elliot Dennis

A touch of darkness
The dark used to be someplace that I looked for you.
It was a place that held secrets and hid you from my eyes but not my hands.
I could reach out for you and once I made contact follow it back to you.
I would find the hand and bring it to my lips tracing my cheek with your fingers.
I would slide down the curve of your arm like the rain seeking the ground, enjoying the friction created by our skin.
My lips grazing all the softest parts of you along the way, the wrist, the crook of your arm, the inner parts of your bicep with a slight detour along your breast and the shoulder.
I find my way to your neck and the ear hanging there like fruit in a tree begging to be nibbled.
It's darker here buried in your neck with the scent of you strong in my head.
I press my lips to your neck feeling the heart beat strong against my tongue.

Exposing the Heart of a Poet

My lips draw back so that I might caress your
neck with my teeth.
My hands find your chin and turn your face to
me so that I can press my lips to yours and
breathe you in.
The contact of your lips makes my head swim
I get lost in shadows supporting myself with only
the contact of our skin.
I pull you into the kiss so that we might share the
same shadow and swim in the darkness
together.

Elliot Dennis

Let the rain touch you
I like it when the rain touches my face
It reminds of babies fingers grabbing at my eyelids and the gentle caress that comes with true affection.
I see people walk through the rain huddled and hiding and I cannot understand it.

The rain is fresh untouched by man and crisp like only nature can provide.
It will strip away your strength and take with it all that makes you weak.
Submerse yourself in it and you will feel baptized in life.
Your skin alive to the most subtle changes around you.
It will begin at the top of your head and like a lover cover every inch of you with its caress.
It will hug every curve of your cheek following the forgotten echo of tears long dried up.
It will slide down your neck like soft lips.

Exposing the Heart of a Poet

It will work its way under your clothes like the exploring hands of a new lover bathing you in its touch.
Your skin will pebble at the chill as each drop slides down your body.
The fine hairs at the back of the neck rising as the drops feel like nails running down your back.
It will make you wet and if you are in it long enough it will make you tremble.
It will remind you to be playful and free.
It will lull you into a relaxed place and make you want to snuggle afterwards.
Listening to the distant drumming
Like a heartbeat pressed against your chest.

I played in the rain today, you should try it.

Elliot Dennis

Haunted
You enter my dreams like a shadow in the night.
You plunge your fingers into my brain taking
control of my senses like a master puppeteer,
plucking at my memories like a virtuoso.
My ears hear the sounds of horror.
The sounds of laughter, tears and running water
the whispers and whimpers of passion.
My nose picks up the scent of vanilla and citrus
enough to make my mouth water.
 I can taste the savory flavor of the old country.
Sweet and hot making me perspire,
Strawberries and cream making me hungry.
I can taste flesh and salt after vigor.
My eyes are filled with visions of angels.
The sight mine but the reflection not my own
but of beauty wrapped in jewels or nothing at
all.
The hands are mine but controlled by something
else as they chase drops of water over pebbled
skin.

Exposing the Heart of a Poet

They slide over soft flesh covering well-used
muscles kneading the aches away with pressure
and rhythm.
I can feel my breath rise and fall faster and faster
as this possession continues.
Suddenly I wake panting and covered in sweat.
I lie down recovering, wandering what my ghost
will bring when my eyes close again.

Elliot Dennis

Distractions
Oh distraction, come and take me.
Come and pull me from my thoughts
Take me someplace I don't go oft enough.
Make me laugh, cry and beg but take me.
Make the things that seem so real yet fulfill me not, ride away on a tide of enchantment.
Make the pains that have no place anywhere physical drift away like smoke in the wind.
Remind me of stolen moments in the dark with conversations held in whispers.
Remind me of the strength and tenderness my hands possess as they touch the fragile.
Remind me of the touch, not my own which knows me better as I blindly follow where it leads me.
Remind me of breathless moments with corded muscles straining, holding on and letting go at the same time.
Remind me how tight my own skin can feel as I am overcome by desire.
Make my blood flow and my head spin as I lose this world.

Exposing the Heart of a Poet

Make the ache turn to burning until I am
scorched to my soul,
Making me grateful for any feeling at all.

First kiss
Do you remember the first kiss?
Not the one with too many teeth and no control
the one that was all gentle exploration.
It may have evolved into urgency and passion
but at first it was discovery.
You found yourself in it and lost yourself at the same time.
It was just the right amount of pressure to make you understand.
 It was someone expressing to you what they could not put into words.
On this New Years Eve
When the clock strikes the end of one and the beginning of another,
I hope that this kiss finds you again.
That the kiss you receive, lets you forget
whatever it is that holds you down and helps you remember how very special you are and that there is love in the world for you.

Shopping tips
There is a reason you don't shop when you're hungry,
You lose the ability to distinguish between fulfilling a simple craving and a true desire.
Life is very much the same;
Do not wait until you are miserable to decide what you want in this life.
Spend more time being happy and fulfilled and in these times surrounded by people that engage you
In environments that stimulate you;
Think about what you want that will nourish your existence.

The little things...

Life is that little puzzle in the Sunday paper
That shows you 2 version of the same scene
You get to see how observant you are.
This is a test of whether or not you are paying attention.
When spending time in paradise
See if you can identify the number of differences in the same experience.
See if what was once a mundane repetition
Can become an appreciation of the nuances.
Take a scene, any you have before you and see if you can see all of the differences
Better still stop counting
Truly appreciate this once in a lifetime moment you have in front of you and participate with everything that is you.